PICTURE SCIENCE

Picture Science

Using Digital Photography to Teach Young Children

CARLA NEUMANN-HINDS

Redleaf Press®
www.redleafpress.org
800-423-8309

Published by Redleaf Press
10 Yorkton Court
St. Paul, MN 55117
www.redleafpress.org

First edition 2007
Cover photographs by the author
Interior typeset in Adobe Garamond Pro and designed by Fiona Raven
Interior photos by the author
Author photo by Lisle Warner, Photo Dynamics, Inc.
Printed in China by Pettit Network, Inc.
15 14 13 12 11 10 09 08 2 3 4 5 6 7 8 9

Sally L. Smith, "How We Learn Rap," from *The Power of the Arts: Creative Strategies for Teaching Exceptional Learners* (Baltimore: Paul H. Brookes Publishing, 2001), 133–34. © 2001 by Sally L. Smith. Reprinted by permission of the publisher and author.

Library of Congress Cataloging-in-Publication Data
Neumann-Hinds, Carla.
 Picture science : using digital photography to teach young children / Carla Neumann-Hinds. -- 1st ed.
 p. cm.
 ISBN 978-1-933653-23-5
 1. Education, Elementary. 2. Photography--Digital techniques. 3. Lesson planning. I. Title.
 LB1555.N38 2007
 371.33'52--dc22
 2006030423

Printed on acid-free paper

How We Learn Rap

(* represents one hand clap;
 ** represents two claps)

I look** I see**
It all comes clear to me.
I see** I look**
A map, a graph, a book
They offer me a hook
Coz it's my eyes** my eyes*
It's my eyes that work for me!

I see patterns and designs
Chart it, graph it, then it's mine.
Add some color, shape, and line
It's in my brain a long, long time
Coz it's my eyes** my eyes*
It's my eyes that work for me!

—Sally L. Smith, *The Power of the Arts*

Acknowledgments

Many thanks to David Croney and photographer Bob Kiss for their initial encouragement to take on this project. I would also like to thank my principal, Silvia Johnson, for permitting me to work on this project at school, and all my colleagues at Codrington School for their support. Special appreciation to Sharon Lashley, our teacher assistant, who showed such great interest and was always there to give a helping hand, and to all my keen students and their supportive parents. I would like to thank all of my friends, who are always there for me, especially my friend Aziza, who helped me get rid of my "German accent" and discussed every single sentence with me.

I would also like to express my gratitude to Karen Worth and Ingrid Chalufour for their expertise and critiques and to my editor, Amanda Hane, for giving me endless help and tons of encouragement along the way. Special thanks to Doug Toft and all the people at Redleaf Press, who worked hard to put this book together, and finally to my daughter, Elise Fatou, for showing such great patience with a mother who was so busy all the time.

Without these people, this book would not have been possible!

Digital photography can play a significant role in helping students to develop inquiry skills. You can help children find reasonable answers by providing them with photographs of what they are studying. When looking at pictures, children begin to think more intensely about the matter at hand. They start to make connections between what they already know and what they are investigating. You and your students can use photographs in countless ways:

- Gather information on a field trip or outdoor exploration by taking pictures of objects that can't be taken back to the classroom.
- Document change over time or cause and effect by taking pictures for days, weeks, months, or hours.
- Classify information by sorting pictures into different categories.
- Create matching games and puzzles to encourage observation.
- Document children's observations with photographs.
- Use photographs to discuss what happened during an exploration and why.
- Use photographs in charts and other displays to demonstrate children's conclusions.
- Help children sequence the steps they took in carrying out their investigation.
- Use photographs to spark discussion and to let children reflect on their learning process.
- Include photographs in a portfolio to illustrate specific skills the children demonstrated or struggled with during their inquiry.
- Create books or presentations about the project to show to parents and the community.

To sum it all up, teachers in early childhood classrooms can use photographs to encourage children to predict, observe, classify, hypothesize, and experiment, and to document, present, and communicate their ideas. Be creative, and you'll probably discover other uses!

Because most young children can't read yet, teachers and parents cannot ask them to find needed information in textbooks or on the Internet. They can, however, provide children with a great wealth of pictorial information. Digital photography is a very effective teaching tool for enriching and enhancing children's visual learning.

Photographs Make Concepts Visible

Photography can make the abstract concrete. Children may initially find it difficult to understand general principles—for instance, that shadows are created when an object blocks light. But if they're shown a picture, they can describe exactly what they see: "I see that the light is facing the tree and behind the tree is a shadow." By giving children photographs of something visually concrete, you can help them explore and understand abstract concepts.

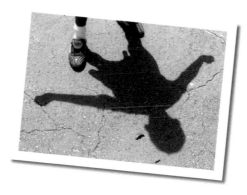

Photography Expands Children's Sense of Time

Children live in the present. They may have difficulty remembering what they did in yesterday's experiment or what a plant looked like a week ago, when it was just a seedling. Showing them photographs of past events reinforces their memory and makes their prior experience available to them again.

Photography Personalizes Materials for Young Children

Giving kids a photograph of a bird that you have clipped from a magazine is great. But showing a picture of a bird that the children have seen in their own playground adds meaning and impact to the image. Producing visuals of themselves or of things they immediately recognize from their own environment captures your students' attention and stimulates their interest.

Getting Started: Using a Camera Effectively with Groups

Many providers are reluctant to let children use cameras because they fear that children may break or lose them. Program staff may think young children don't have the ability to use a technical instrument like a camera. If your program has only one or two cameras, you may be especially concerned.

Be assured that starting at about age four, children can use a camera safely and responsibly. In my experience, they are eager to do so and take extra care in handling such an important instrument. The digital cameras on the market today are very durable and reliable. The risk that children will damage a digital camera is low.

Remember, too, that in the form of computers, digital technology is already being used in classrooms all over the world. In many ways, a digital camera is simply an extension of the computer. Why not use both of these powerful tools in early childhood education?

Of course, children will need your help in learning how to use the camera appropriately and how to take effective pictures. Make sure the children understand that a camera is not a toy but a tool and that they need to handle this precious tool with care. Encourage questions and discussion while they are learning to handle the camera, keeping the following suggestions in mind:

Explain the Basic Parts and Functions of the Camera

Show children how to hold the camera and which button to press. Demonstrate how to focus and how to select and frame a picture in the viewfinder and on the camera's LCD (liquid crystal display) monitor.

Model Appropriate Behavior during Picture Taking

Remind children to concentrate, take their time, and stand still while taking photographs. In addition, show your children how they can get several different views of a subject by taking photographs from different positions—for example, while standing, kneeling, or lying down.

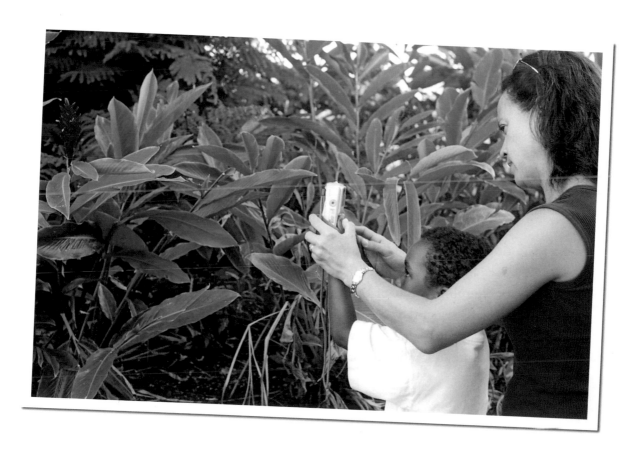

Sample Inquiry: Shadows

Where there's bright light, there's shadow! And children are captivated by shadows. They love to make different shapes with their hands and bodies, watch how their shadows move and follow them, and see how tall their shadows can become.

Several children in our program became curious about their shadows: *Where do they come from? How do they change? What makes shadows change?* I decided to use these questions to lead the children in an inquiry.

Asking a Key Question

We began by figuring out what it was that the children wanted to learn. During a physical science unit about light, our five- and six-year-olds had already explored where light comes from. The children knew that light comes from a source such as the sun or a lamp. But what creates shadows and why do they change? This is what we wanted to find out.

Collecting and Analyzing Data

We began our exploration by going outside at different times of the day and looking at shadows of different objects. These included trees, buildings, and the basketball pole. We looked for places that had full light and that lacked other shadows that would distract from the ones we wanted to observe.

We also investigated our own shadows. The children moved their bodies up, down, and sideways into all kinds of positions to create different shadow figures with their hands, arms, and legs. They had fun and found they could make endless varieties of shadow figures with every movement of their bodies, including shadow animals such as elephants, big birds, and dangerous monsters. We took photographs of our shadows and noted the time at which each picture was taken.

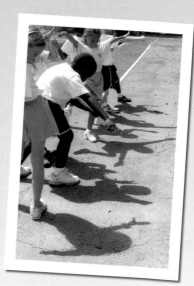

One result of this activity was that we observed how shadows changed over time. The children discovered that afternoon was the best time to take shadow pictures, because shadows become long then.

Demonstrating Conclusions

I suggested that the children use their photographs to make a chart illustrating when shadows were tallest and when they were smallest. During this activity, we discussed the position of the sun, why it is that shadows are sometimes large and sometimes small, and why we can hardly see any shadows on a rainy day.

The children came up with accurate conclusions:

- Light comes from a source, like the sun.

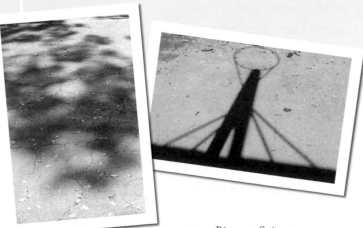

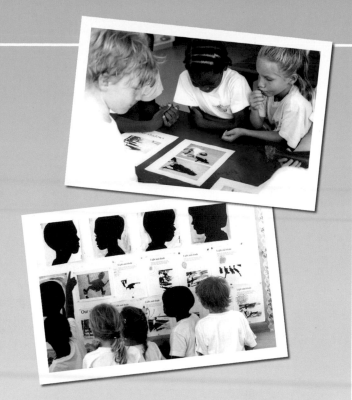

- Shadows are made when light falls on a solid object, such as a person's body, and blocks the light. The blocked area is a shadow, or shade.

I also asked the children to identify the position of the sun in each photograph. By the end of this activity, the children understood that shadows change according to the position of the sun (our light source) relative to the location of the object or person blocking the light. More specifically,

- The sun must be at your back to cast a shadow in front of you.
- The size of the shadow depends on the angle of the sun to the earth.
- When the sun is blocked by clouds, the light is diffused, so it doesn't cast shadows.

Making the Process of Inquiry Visible

We then came back together as a group and reflected on the project by talking about the sequence of our activities during this investigation: what we did first, what we did second, and what we did after that. The pictures we took helped us recall the order of our activities. Next we discussed why we went outside at different times of the day and how our photographs helped us learn about shadows.

Creating Documentation and Assessing Learning

After our photo shoot, we made a "shadow book" and displayed photographs on the classroom board for everyone to enjoy and consider.

While we sorted the pictures, we tried to guess whose shadow was pictured in each photo. Children could quickly identify their own shadows, and pairing photographs of other students with pictures of their shadows was a lot of fun. An individual photograph taken during this exploration of shadows could be integrated into a child's portfolio to demonstrate the child's active engagement in the inquiry.

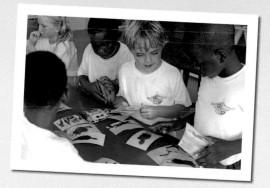

Other Notes on This Inquiry

Give your children enough time to play around with their shadows and to enjoy their experimenting. Let them use their imaginations and express themselves while discovering yet another scientific concept. Creative play and learning go hand in hand!

1

Photography for Collecting and Analyzing Data

In any inquiry, you and your students collect data to try to answer a specific question. Your job is to help them focus their exploration on the key questions that sparked their investigation and to make specific observations that may lead to answers. Observations can be recorded and organized for analysis.

What Is Data?

Young children are naturally inclined to collect information. Watch them as they pick up something of interest—a rock, a leaf, a shell, a seed, even a piece of string. Children want to know how objects look, feel, smell, or sound; how they can be manipulated; how they change; and what different shapes, colors, and sizes they come in. All of these are important qualities to investigate.

Data, however, is not merely a collection of information. Rather, it is *information collected to answer a specific question.* The information that children gain from their experiences can be turned into data, transformation that occurs as part of the process of inquiry.

Turning observations into data involves selection. This is something that young children may forget, especially during an exciting outing. With a digital camera in their hands, they may initially be tempted to take photos of anything and everything they see. This is when you can offer some help to focus their creative impulses. Remind your students of the key question for their investigation, and direct them to the specific

subject for their photos. On a given day, that subject may be a pet's behavior, changes in cloud patterns, stages in the melting of an ice cube, steps in mixing colors, ways to make bubbles, or the steps they followed to build a tower or a bridge out of blocks.

Children can gather information and record their observations in a variety of ways—for example, by

- Collecting objects
- Observing and taking notes
- Making drawings
- Building three-dimensional models
- Making audio or video recordings
- Taking photographs

Photography as a Way to Collect Data

Taking photographs of objects or events is a particularly effective tool for collecting data in early childhood settings. Once you have clarified the specific questions your students are seeking to answer, you can arm them with a camera. After every photo shoot, they will come back with lots of data to analyze. Photography can make some otherwise difficult-to-understand data visible to young children.

Capturing digital images of a child's discovery does not take long. Such visual data can be stored and organized on your computer to be integrated into many types of documents: charts, graphs, notes, booklets, portfolios, and so on. Because this information is in digital form, it can also be easily saved, sorted, and edited into many kinds of electronic files. These files can be used for unlimited purposes and are available for you and your children to work with anytime.

Photography as a Way to Analyze Data

The word *analysis* often evokes a dry, cold, intellectual act. But analysis can also be an active, creative, and passionate process. When children analyze data, they get to take their observations apart, examine them,

view them from different angles, rearrange and sort them, and then put them all back together again.

Analyzing data means taking records of observations and then comparing, categorizing, and looking for patterns in them. A natural outgrowth of this process is discussing and explaining recorded data, coming to conclusions, and eventually asking new questions.

When children look at photographs that represent their own experiences and observations, they automatically begin to analyze the information presented. Images spark conversation about their experiences during the investigation, provide visual clues about the subject being studied, and stimulate exciting new questions. Combined with the teacher's constructive questioning, photographs are powerful tools to support the development of beginning reasoning skills in young children and can help them to develop the cognitive skills necessary to analyze data. Children can use photographs to actively practice these skills.

In this chapter, you'll find suggestions for helping students analyze data by exploring a variety of concepts:

- Change over time
- Cause and effect
- Parts of a whole
- Similarities and differences

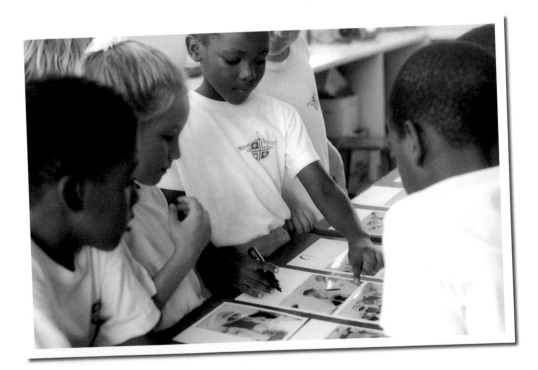

Young children know intuitively that things change. Your students, like all children, develop a sense of change through experiencing it in their daily life. You can support this development by encouraging them to observe and record appropriate examples of change over time.

Children in the preschool classroom can be guided to observe cyclic changes (such as day and night), predictable trends (such as growth and decay), and less consistent changes (such as the arrival of a storm). Your children can identify rainy and sunny days and observe weather changes over a short or long period of time (day by day or month by month), and they can also begin to identify and observe different forms of clouds. They can observe how a fruit tree changes over time, recognizing when the tree produces seeds, flowers, and fruits, and how its leaves change and fall in autumn.

Children should also have the opportunity to observe rapid changes, such as the movement of waves in water, and gradual changes, like the erosion of soil. By using a variety of examples, you can teach children to recognize that rates of change may be fast or slow and that many changes occur naturally, while others are induced by humans.

As you foster children's sense of wonder and help them become more aware of various changes, they awaken more and more to their surroundings. You can encourage them to observe their environment more closely. With your help, they will begin to recognize specific changes that occur repeatedly. Over time, they will discover that humans, animals, and plants go through a series of orderly changes during their life cycles.

Using Photography to Document Specific Changes over Time

Photography offers simple and powerful ways to make change visible. For example, your class can start to explore weather changes by taking daily, or even hourly, pictures through the classroom window. Choose a particular area outside your classroom and take regular pictures of it from the same viewpoint. Help your students document rainy, sunny, and cloudy days over a whole week, month, or year. They can also collect data by taking one weather photograph each month over a long period—for example, a whole school term or year. This works particularly well if you live in an environment with four visually distinctive seasons. With these pictures as supporting evidence, children can learn that weather changes all the time, in a recurring order.

Four- and five-year-old children are already aware of their own growth, but try asking them how they know that they grow. I asked the children in my class to look at each other and see if they could figure out how they grow. We all stared at one girl, but, no, we couldn't see her growing. If she was growing all the time, why couldn't we see it?

The children came up with very interesting explanations. "She is growing from the inside and that's why we can't see it from the outside." "She needs energy and she needs food." "She grows at night, when she sleeps." "If we go to her house and watch her sleeping at night," I asked, "will we see her growing?" Most of the children shook their heads—no, probably not.

We had a problem: How come we couldn't see growth by just looking? One of my bright boys figured it out and shouted: "She needs more time! She grows slowly." Yes! Growth takes time. Our eyes are unable to see growth moment by moment, but our photographs can tell the story.

That day, we measured all the children in class against a growth chart on the classroom wall, recording their heights and the date on the chart. We also took a picture of each child in front of the chart. At the end of the year, we took new photographs so we could compare and analyze them with the earlier pictures. The children found out exactly how much they had grown over this period of time.

Stimulate the spirit of inquiry: take pictures, and capture the changes.

To help children collect and analyze observations over time, guide them to an understanding of sequence. *Sequencing* means arranging events, actions, or objects in a chosen order. In daily life, sequence can be found in telling a story or giving directions that involve a series of steps. A usual school day follows a certain sequence of events and activities, and teachers use sequencing every day in their verbal instructions to children.

Children in a preschool classroom often organize their world differently than adults or older students; you cannot assume that they sequence their observations in the same ways that you do. Young children do not have fully developed ideas about how events unfold in space or time. They don't yet have a clear sense of the clock or calendar and can't always use these tools to store and retrieve memories in an adult way. Preschool students first need to understand basic spatial and temporal concepts such as *beside, under, on top, between, next to, first, next, then, before, after, finally,* and *following.*

With sequencing activities, you can lead children to a better understanding of these basic concepts. As young children gradually refine their visual perception, explore their environment, and make sense of their world, they also learn to sequence events and they begin to recognize the importance of order. Children start to understand that every event happens at a place and time, that events have a starting point, and that they lead to other events.

Sequencing skills depend on basic thinking skills, which are vital for all learning. Learning sequences is necessary for solving problems in daily life. Later on, sequencing skills become necessary for interpreting literature and solving math problems.

Sequencing is also essential to pursuing scientific inquiries. Through sequencing activities, children develop better skills at observing. They begin to notice and understand change.

Using Photo Series to Develop Sequencing Skills

One way to support the development of sequencing skills is to provide children with lots of activities based on photo series. Create a sequence of photographs to document and demonstrate change over time. Provide children with digital images of events that happen in a particular order: growth from seed to plant, the life cycle of a frog or butterfly, or seasonal changes in the weather. Such sequences allow them to revisit and reconstruct an observed process and to draw their own conclusions.

Help children organize a number of photographs in chronological order—one kind of sequence. Ask them to point out the differences they see between the pictures that were taken first and those taken later. Encourage children to predict changes in their environment over the days, weeks, or months to come. Then use photographs to compare their predictions with their actual observations.

Always encourage children to develop their own explanations for how things become the way they are. In addition, help children create their own photo series and publish them in the form of topic-related booklets and charts. Ideally, these activities will raise new questions to think about and discuss in class.

Use photo series to document learning activities in your classroom from beginning to end. Create simple sequence strips or picture cards with three or four pictures per series. In effect, these photographs document the process of inquiry itself: the children practice sequencing skills, reflect on their activities, think about the subject matter, and interact and communicate with their peers—all at the same time. They can order the photographs to answer the following questions:

- What did we do first?
- What did we do next?
- What did we do then?
- What was the outcome?

Sample Lesson:
How Do Seeds Grow?

As part of their investigation of plant growth, my class of four- and five-year-olds each planted a bean seed in a small pot of soil. Over the next three weeks, they observed their pots closely for any signs of growth. Within a few days, the seed broke open and a tiny sprout appeared through the seed coat and soil. A stem with little leaves grew upward and the leaves unfolded. The bean plant quickly grew into a bigger plant. My students and I documented these developments in photographs and used the photographs to demonstrate change over time.

After three weeks, we looked back over the photographs of our growing plants. We discussed what happened to the seeds and how the plants changed from day to day. Using photographs helped the children recall what their plants looked like at the beginning of the investigation, notice important physical details of the plants, and understand the process of growth.

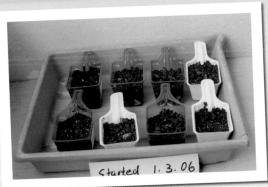

We planted the bean seeds in the soil.

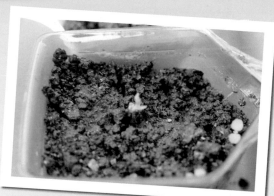

The first leaves broke through the soil after three days.

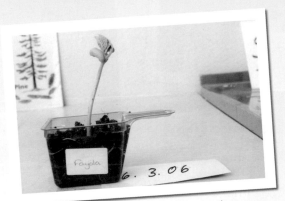

This is Fayola's bean plant after six days.

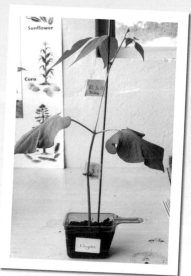

This is Fayola's bean plant after fourteen days.

Sample Lesson: Growing Flower Seeds

As children put photographs from their investigation in chronological order, they learn to look closely, observe differences, and understand how objects change over time. During our inquiry into what seeds are and how they behave, we planted flower seeds in small trays and watched them grow. We took photographs over a period of three weeks to document the growth of the plants as they developed flowers.

anything growing—but sorting out the remaining pictures was much more difficult. In one picture, the plants would be very tiny, and in the next picture, they would only be a bit bigger.

I observed that it was still challenging for some of the four- and five-year-olds to differentiate between details, and it was often very difficult for them to handle a series of many pictures. For these reasons, take simple pictures that demonstrate clear changes and that do not

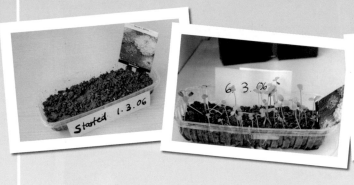 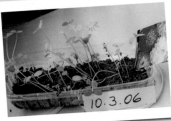 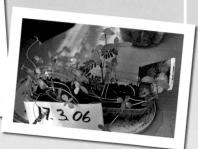

The children were then asked to put those pictures in chronological order and find the proper sequence. They had to look at the pictures, differentiate and compare the size of the plants, and make decisions. It was easy to decide which picture came first—the one where you couldn't see

include a lot of distracting information. You might begin with just three or four pictures and add more as the children become increasingly adept at differentiating and sequencing them. Children must be given many opportunities to practice sequencing skills!

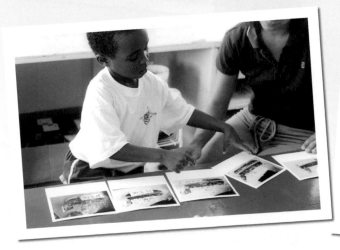 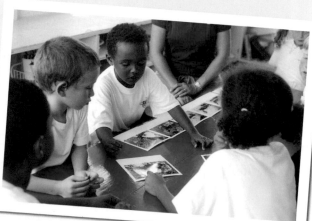

Young children begin to gain a basic understanding of cause and effect through actively exploring and searching for relationships between events. In the course of their play, they are already observing that the occurrence of one event makes the occurrence of another more likely. For example, when children stack blocks too high and they fall down, or observe that dark clouds always form before a storm, they are already learning about cause and effect. As children make such observations, they develop questions about these relationships. Guide them in making educated guesses and searching for answers. Encourage them to think about causal relationships between the properties of an object and the way it moves, the possible causes of growth, and the patterns of dependence and independence in events.

For example, you might ask them to predict what will happen if they:

- Put seeds in a little water?
- Water a plant or choose to let it dry out?
- Put a potted plant in full light or in a dark spot?
- Take ice cubes out of the freezer and put them in a warm place?
- Build a ramp and put a round object on top, followed by an object that is not round?
- Mix one color with another?

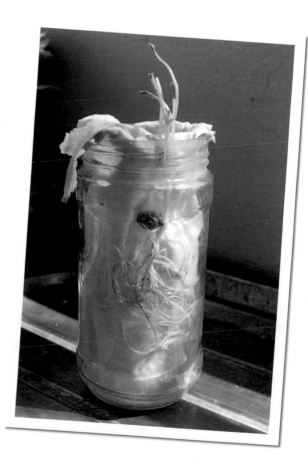

Sample Lesson: Mixing Colors

As young children begin to recognize, identify, and name colors, they also become eager to experiment with them. They love to use paints and mix new colors in art class. You can use this curiosity to lead your students in a scientific investigation of how colors change when they interact. For young children, this is magical—almost like mixing potions.

Our initial discussion about mixing colors led us to these questions:

- What happens if we mix blue and yellow?
- What happens if we mix red and yellow?
- What happens if we mix blue and red?
- And what happens if we mix all the colors?

I provided the children with red, blue, and yellow paints—the primary colors—and let them explore what happened when they mixed the colors in the combinations mentioned above. "Wow, blue and yellow make green!" was just one of the many observations we documented with color photographs during this exploration.

Even after children discover the answers to their questions about mixing colors, they don't always remember what they did. I've heard older students ask: "What was it we did to make purple?" You can repeat color-mixing activities over and over again; children always enjoy these explorations, and you can remind them of what they learned by showing them the photographs.

Document the results of color mixing activities with photographs taken by the children, and use these visuals to reinforce the conclusions that they reached. Display the photographs on the classroom board, make a color book, show the pictures during a discussion about colors, or make a color chart. When these photos are displayed in a prominent place, they can spark a discussion about color mixing at any time: *Look at the pictures and tell me what happens if we mix yellow and red. What do you see? Yes, now you remember: It makes orange.*

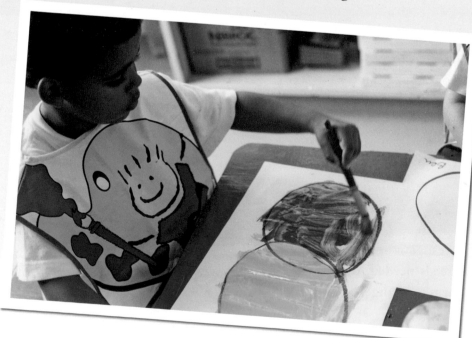

In the preschool classroom, children begin to understand that everything is made up of different parts and can be divided into separate components. Young children often find it easier to observe parts than wholes. In order to understand the structure of a whole they need many opportunities to build component parts into wholes. Children also learn that parts can be rearranged and reorganized in different combinations to form new wholes.

You can easily support and enrich investigations into part-whole relationships with photographs. Help children create a caption that identifies the subject of each photograph and labels its parts. In the process, children learn to name different parts of each whole—for example, the parts of their own body, the parts of an animal's body, or the parts of a plant. Through labeling, children build on their prior knowledge of words and gain important new vocabulary. You can also use this time to talk about the function of each of the parts and how each part fits into the whole.

One caution: labeling can easily become an exercise in learning by rote and drilling facts. Your challenge is to make it part of the larger process of inquiry. Keep the focus of an investigation not so much on labeling as on observing closely, naming the parts, and talking about how the wholes and parts are related.

When our three
the parts of a
plants into the
at; a simple an
Taking a close
discussed thei
found out that
number of fea

For
and con
words *fl*
in such
thought
parts.

As part of the science unit Discovering Nature around School, our three- and four-year-old children took their very first photographs: pictures of trees that surround our school. My aim was to teach them that trees have different parts, just as people and animals have different body parts. To make a puzzle, I chose a picture I'd taken of a big, beautiful mahogany tree that stands in front of our school building. In my picture, the mahogany tree was framed on both sides by other trees, which made it easier for the children to re-create the whole picture. Notice the white edge around the picture, which also was helpful. Reassembling the six pieces of the photograph became a challenging task. The children had to use a lot of thinking skills in order to reassemble all the pieces accurately. For some of them, it was too difficult.

Putting the puzzle together offered the children a good opportunity to name the different parts of the tree and to think about the positions of those parts.

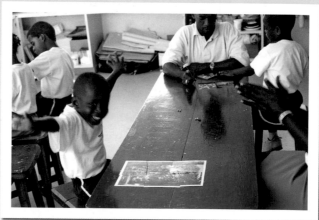

Jackson putting the puzzle pieces in place: "I did it!" (applause).

Matching and classifying games offer great opportunities for exploring the observable properties of objects and the relationships between them. A young child who is able to sort a set of photographs according to different attributes, such as color and size, has mastered the first stage of the concept of classification, which contributes to understanding science. Matching and classifying activities are concrete, task-oriented activities in which children use the knowledge they already possess to make new connections and to organize information differently.

Eventually most children begin to understand that classifying things makes it easier to study them. Once things have been classified, children know roughly what to expect about how those things look and behave, and knowing that helps them to make predictions.

By matching, sorting, categorizing, and positioning, children also learn skills that are essential for later competencies in science, math, and reading. You can use classifying activities to let children practice important inquiry skills, encouraging them to:

- Ask questions like *Why does it match?*
- Make decisions and solve problems with appropriate strategies.
- Use logical reasoning.
- Observe by discovering and describing likenesses or differences.
- Recognize that objects can be sorted out by using one or more attributes; doing so develops critical and flexible thinking.
- Make connections by exploring and understanding relationships.
- Expand vocabulary by using new words to label things.

Remember that young children cannot use the sophisticated classification schemes that scientists and other adults might use. In your classification activities, let the younger students (ages three through five) classify items into just two groups—for example, living or nonliving things, liquids or solids, animals with two legs or animals with four legs, soft objects or hard objects. Older students (age six and up) can classify things into several categories at the same time.

For matching and classifying activities, you can use both concrete objects and photographs of objects. You can ask children to sort a series of photographs into different categories. Whereas some objects, such as plants, may not last and some, such as living animals, may be impractical to physically sort, photographs of either provide engaging, functional materials that can be used again and again.

You can also use classifying and matching activities for assessment purposes. A child who finds the correct matching pair or who is able to classify different objects accurately has already developed early strategic thinking skills and is probably well on her way to understanding the introduced concept. A child who cannot successfully find the right matching pairs probably does not yet fully understand the lesson's objective.

Remember that sorting, classifying, and matching can become tools for rote memorization rather than parts of children's own investigations. Although memorization has its strengths, it is not central to inquiry-based learning as presented in this book. In the spirit of inquiry, remember that *classifying is a way to analyze data in the service of answering a specific key question.* For examples, see the sample lessons that follow.

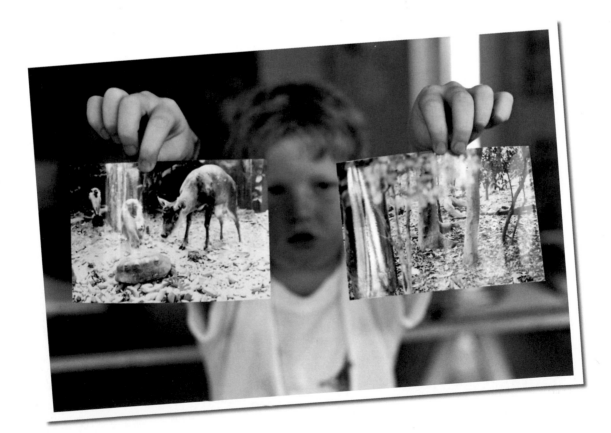

Sample Lesson:
Living and Nonliving Things

Although most young children have a good understanding of the differences between things that are alive and things that are not, some of them still find it challenging to assign things in their environment to one of these two groups. When it comes to learning this kind of classifying, sorting digital photographs is a great way to begin.

During our science unit on discovering nature, the children discussed the differences between living and nonliving things. Based on their prior experiences, they managed to identify some key characteristics of livings things. For example, living things grow, reproduce, and depend on nutrients such as food and water to survive.

After this discussion, we went outside on a photo hunt for living and nonliving things around the school. The question that guided our data collection was *Is this a living or a nonliving thing?* I asked the children to point out several objects for picture taking and to assign each object to one of these two categories. Through this enjoyable outdoor activity, the children were able to apply knowledge they already had, revise their ideas about living and nonliving things, and improve their classifying skills.

A day later, in the classroom, we looked at the printouts of the photographs and practiced classifying again by dividing all the pictures into groups of living and nonliving things. I asked the children to put the pictures of nonliving things on a yellow posterboard and the pictures of living things on a green one. As they did this, they answered these questions to analyze their photographic data:

- What is the thing that you see in this picture?
- Why did you choose to take a picture of it?
- What does it look like?
- Is it alive or not alive?
- How do you know this thing is alive or not alive?
- Does it move?
- Do you think it can grow?
- What did you notice?

After they'd sorted all the pictures into the two groups, I asked the children to describe the similarities and differences between the two groups. This was an excellent way to practice comparing and contrasting and to reinforce our earlier discussion about the qualities of living and nonliving things. After all the photographs had been sorted into the two groups, we decided to make a chart using these photographs to display what we had learned.

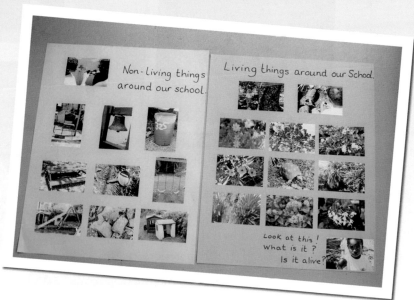

Sample Lesson:
Scavenger Hunt

The following activity was part of our study of nature around the school. It was designed to develop awareness of details in our natural environment and to strengthen the children's ability to read the information provided in pictures.

Finding matches was not an easy task. Some children ran around with their photo card in hand, overwhelmed by all the choices of plants around our school and not knowing where to start. Others immediately found the plant that

To prepare for this activity, I took lots of close-up photographs of plants around the school and mounted them on cardboard. I produced various photo cards, all showing details of the plants I'd chosen.

With these photo cards in hand, the children embarked on an exciting scavenger hunt to find the matching plants. Each child was given one card at a time.

matched their picture. I gave some of the children hints to lead them closer to the area where they might find their match. How accomplished they felt when they found it! After finding one correct match, all the children wanted more, so I gave them each another photo card and they continued their hunt.

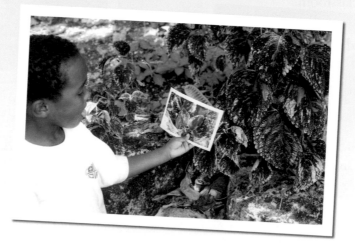

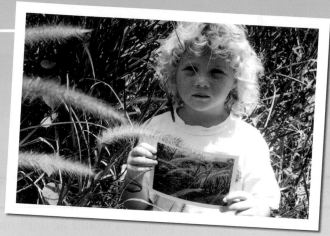

If you play this game more than once, you can mix up the pictures and provide each child with a different picture, creating a totally new task for each child. It takes awhile before each child has found all the matching pairs.

You can organize a scavenger hunt in many ways. For example, you can provide the children with a map along with the photo cards, showing the places they have to go in order to find the matching objects. Or you can give the children just one picture to start with and hide an envelope with the next photo card at the site of the first match. You can continue on like this, leading them from place to place, until they arrive at their final destination.

There are endless ways to use and play with photo cards—all of them are active and task oriented, and all of them offer the potential for children to use their thinking skills. When they seek and collect different items, children are practicing basic scientific skills: searching, observing, and selecting among objects.

A Note on Games

Remember that children learn through play. If you integrate photography in your teaching, think about some playful ways to use it.

Games, including puzzles, are inherently motivating. They capture children's interest and provide opportunities to practice many skills important for success in school: problem solving, questioning, observing, communicating, sequencing, manipulating, and sharing.

Through games you can introduce the four basic concepts presented in this chapter, in addition to many more. With digital photography, you can let your imagination roam freely to create customized picture games for whatever you want to teach. Use these games to reinforce and strengthen what the children have learned from their own explorations. For young children, these games should be simple to use, clear, colorful, and fun to do.

Sample Lesson:
A Field Trip to the Beach

As part of our science unit on discovering nature, our class of five- and six-year-old children went on a field trip to a nearby beach. My objective was for them to learn to classify the objects they found into groups of living and nonliving things.

We were well prepared with all kinds of tools: magnifying glasses, plastic bags and cups for collecting things of interest, scoops for picking up things that could be too dangerous to pick up by hand, small shovels for digging, and (last but not least) three digital cameras. The class was divided into three small groups, each with a camera.

Before the trip we discussed what the children might find on the beach. They predicted that they

a lot of crab holes, and everyone was interested in catching, or at least seeing, a crab. (The crabs knew better and hid.)

Back in the classroom the next day, the children studied the photographs and thought about which of the pictured objects belonged to the category of living organisms and which belonged to the category of nonliving things. They also tried to name the subjects in their photographs. There were also some new questions: *Where did all these objects originally come from? How did they end up on the beach? Was it the wind, the sea, the river, or people who brought them there?*

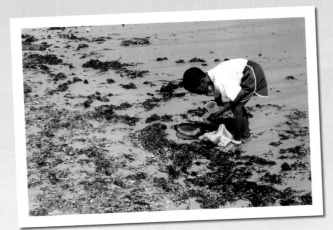

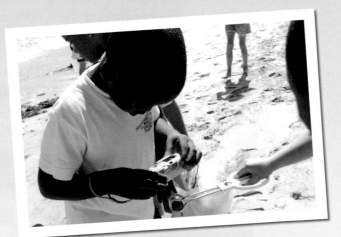

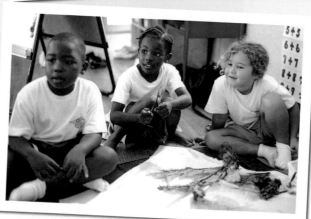

would probably find coconuts, shells, driftwood, pebbles and rocks, crabs, seaweed, and trash.

We went to a beach called Bath, where a small stream comes down to the sea. I asked the children to use a magnifying glass to look closely at things they found and decide which objects were worth photographing. Of course, they found and collected many more interesting things than they'd expected to find: for example, many different types of rocks and intricate sea fans. We saw

The children were also excited to see pictures of themselves during the trip, and they discussed what the photographs revealed: "Look, what is Kenya doing in this picture?" "Why did she take a picture of this flower?" "Look at me, I found a sea fan! Is a sea fan a living thing or not?" "Why is Kimani digging a hole in the sand?" "Oh, we know: He's looking for crabs!" "Why do you think he couldn't find one?" "Look at this beautiful orange rock. Who found it?" "Who took the picture of it?" The photos helped to make the process of inquiry visible.

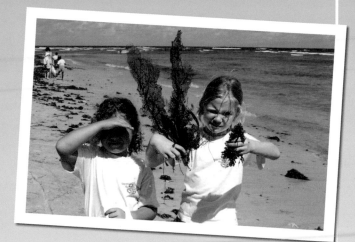

Several days later, the children and I pasted the photographs of the objects they had found on a large sheet of poster board under the heading Living and Nonliving Things on the Beach. On another large sheet, we pasted photographs showing the children in action at the beach so that they could see themselves actively engaged in scientific investigation. This board was titled Our Trip to the Beach. We exhibited our boards on the classroom wall.

The result of this field trip and our follow-up activities was a lot of conversation among the children about their experiences. They expressed a sense of wonder about the great variety of natural objects they'd found on the beach. The children realized that every object we found or photographed was unique, beautiful, and interesting. Every object came from somewhere; had a name, a history, and a purpose; and could be studied in the spirit of scientific inquiry.

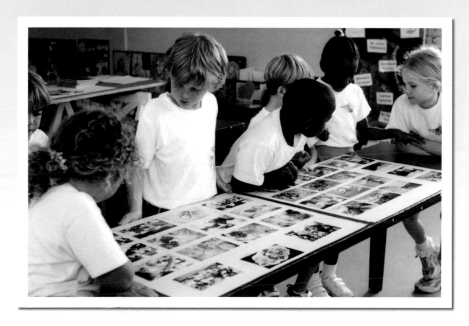

learned. Over the course of several weeks, for example, children's inquiries might lead to the general conclusion that different animals have different homes. Use your ever-expanding photo data bank about the homes of many animals, including those found in the wild, on farms, and in the homes of pet owners. The same pictures can be incorporated into many other activities.

You will find it interesting to present children with pictures from your photo data banks at the end of a specific exploration or at the end of a term. Ask questions to determine whether the children are able to explain what is going on in these pictures. Can they remember what they learned and state their conclusions in simple, complete sentences? Can they match their conclusions with the appropriate images?

Use Charts to Demonstrate Conclusions

One excellent way to use photography for demonstrating children's conclusions is to produce topic-related charts that include a series of images from an inquiry. Large, colorful digital images make charts come alive and leap off the page or a bulletin board. Include photographs taken by your students, and see how excited they become when they see the results of their efforts.

Charts may seem simple and obvious to adults, who usually have many years of experience in seeing and interpreting data in graphic form. Young children, however, do not yet have this degree of visual literacy. For them, charts are new and vivid ways to display abstract ideas or relationships concretely. Because charts draw attention to and organize data in visible ways, they can provide meaning at a glance, but only after children learn how to interpret them.

Charts also make it easier for children to remember information, and they can provide exciting springboards for discussion. By making charts, you can help children learn to organize information and develop and articulate their conclusions.

Tips for Making Charts

When you are creating charts for young children, remember to keep them simple. Focus on one conclusion at a time, and make sure that each chart can stand alone. Too many photographs can overwhelm young children, so display only a handful that can be easily understood. Here are other suggestions for making your charts effective:

- Write the question or conclusion you are demonstrating at the top or the bottom of the chart.
- Write the text in large letters.
- Post charts at the children's eye level.
- Use the word-processing and photo-editing software on your computer to create charts.

Using Photographs in Flowcharts

A flowchart presents procedures or processes from beginning to end. Use photographs to illustrate the steps your students took during an investigation. Then create a chart to demonstrate the relationships between these different activities, tasks, or events.

Flowcharts that include digital photographs can also demonstrate change that occurs over time or a visible cause and effect. Using simple text and digital images, your students can create flowcharts to demonstrate how they built a terrarium or the life cycle of frogs. The key question for a particular investigation—for example, *How does a plant grow?*—can be used as the title of your flowchart.

The Life Cycle of a Frog

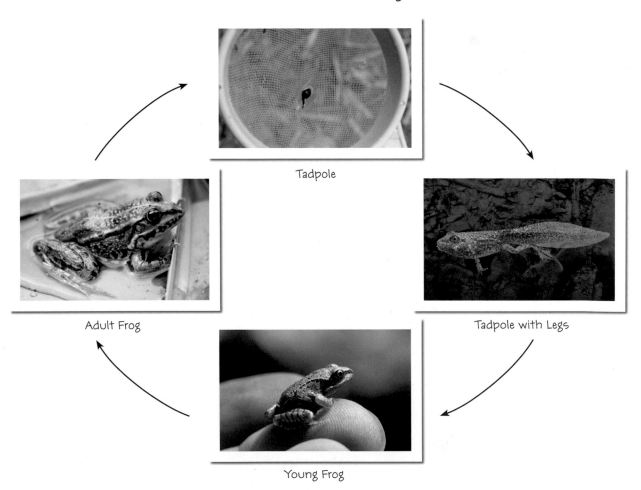

Tadpole

Tadpole with Legs

Young Frog

Adult Frog

Using Photographs in Organizational Charts

Organizational charts show how parts of a whole are organized and ranked according to their relationship to each other. When used in these charts, photographs can show the structure of a whole system as well as its different parts.

For example, children can make a chart demonstrating the parts of a plant or the body parts of people or animals. They can use organizational charts for sorting and classifying pictures of objects into categories based on specific attributes—for example, they can group pictures of animals based on how many legs they have, or classify pictures of leaves by color or shape.

The Parts of a Plant

Flower

Stem

Leaves

Roots

Using Photographs in Pie Charts

Pie charts depict parts as proportions of the whole, which is represented by a full circle. These charts can be used to demonstrate conclusions generated by "how many" questions:

- How many rainy or sunny days did we have last week?
- How many children in class have blue, green, or brown eyes?
- How many children in class have cats, dogs, birds, or rabbits as pets?

When making pie charts for young children, remember to include no fewer than two and no more than eight segments. Include a photograph to illustrate the subject of each segment.

What Color Eyes Do the Children in Our Class Have?

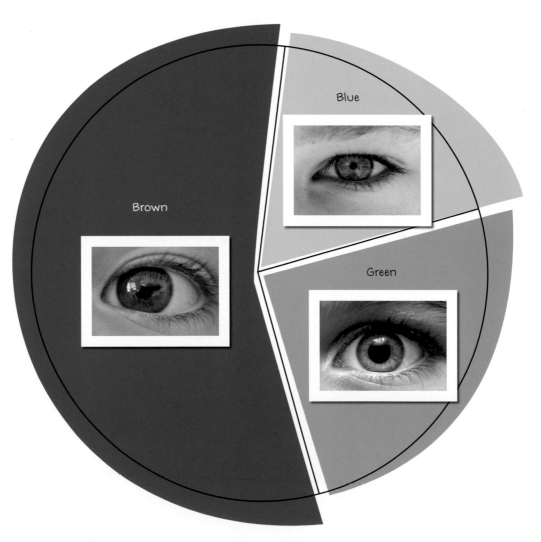

Using Photographs in Tree Charts

Tree charts help children to demonstrate conclusions that branch out from general to specific. A common example is the family tree chart, which begins with the name of the family (such as "The Keane Family Tree") on the trunk and then branches out to show siblings, parents, grandparents, aunts, uncles, and cousins. Other relationships can be shown in the same way.

For instance, the trunk (center) of your tree chart can be the key question *What are living things?* Photos of a person, an animal, and a plant can be connected to this question as separate branches. Images of animals can then be grouped into those that live on land, in water, and in air. Each of these groups can occupy its own branch in the tree chart.

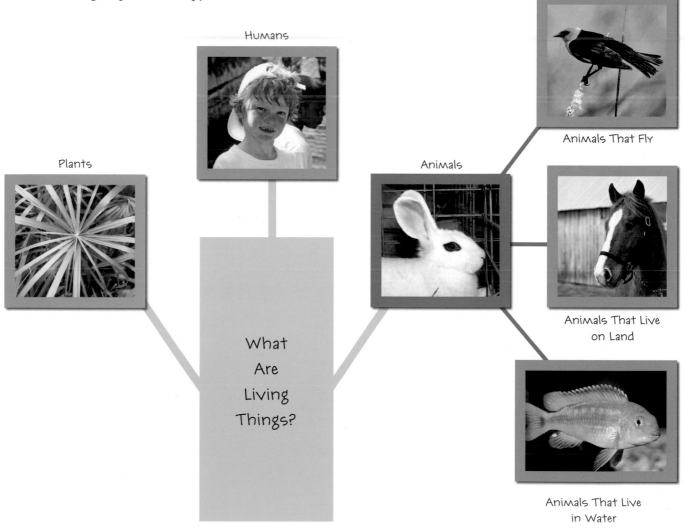

Humans

Plants

Animals

Animals That Fly

Animals That Live on Land

Animals That Live in Water

What Are Living Things?

Using Photographs in Growth Charts

Many parents create growth charts for their children. You can make such charts for the students in your classroom. Tape a piece of butcher paper to the wall, and mark off the inches up to five feet. Create a mark to document each child's height on different dates throughout the year. On that date, take a photograph of the child. Then create a chart with the photographs showing the child's growth throughout the year. Over time, your growth charts will demonstrate changes in the children's overall appearance as well as changes in their height.

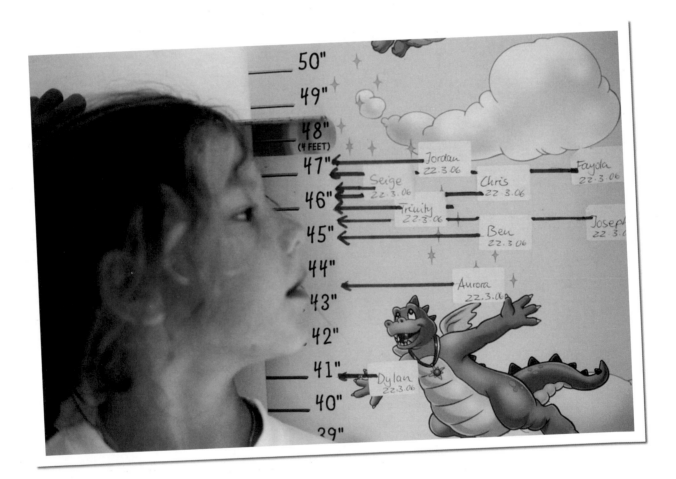

Sample Lesson:
Where Can We Find Seeds?

During one term, our class of four- to five-year-old children focused their scientific investigation on the parts of a plant. The children took a special interest in seeds and generated some questions: *Do all plants have seeds? Do all plants have the same kinds of seeds? Will we find seeds in the same place on each plant?*

The children investigated many plants while looking for seeds. I brought various fruits into the classroom and asked children to predict whether they would find seeds in them or not. Then we cut open an apple, a tomato, and a cucumber and looked closely at their seeds, using the magnifying glass—a new and challenging skill for the children. The seeds looked very different. (The children enjoyed the messy aspects of this activity, and their favorite part was eating the cut-up fruits.)

The children recorded their findings on a Where to Find Seeds worksheet. They attached different seeds to this worksheet and drew a picture of the matching fruit next to each seed. They also took photographs of the fruits and their seeds and made a chart using the photographs. Photographs from this unit and several related inquiries helped to reinforce and clarify a number of new conclusions:

- Plants grow seeds.
- Fruits have different kinds of seeds.
- Seeds can be found in different places on various plants.

Fruits Have Different Kinds of Seeds

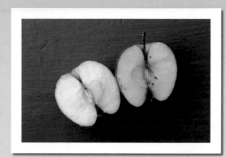

Apple

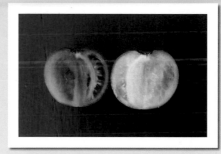

Tomato

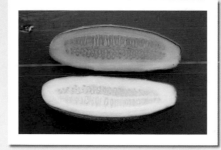

Cucumber

You will have endless opportunities to reuse photographs like these. The same pictures can be used for a matching and classifying activity. For example, make photographs of various plants and their seeds. Discuss what the seeds of an apple, tomato, and cucumber look like, and then ask the children to match photographs of individual seeds with photographs of the corresponding plants.

A field guide is an illustrated book that provides descriptions of plants, animals, or objects found in nature—in the field, so to speak. Producing a field guide with children is an exciting project that includes several steps before it is completed.

Field guides provide a survey of information. Although they usually do not demonstrate specific conclusions from an inquiry, they can be used to summarize information that children have collected during an exploration. You can use this summarized information to initiate new and more specific questions, such as *What do the animals in our neighborhood have in common? What do you think they need to live?*

You can find a multitude of interesting subjects for your field guides. Just use what is available and of special interest to your students. If your school is located in a city, make a field trip to a nearby park or playground. Such explorations can become the basis for a field guide. Or produce a field guide about different types of buildings near your school. Even closer to home, you and your students can conduct a photo shoot of colors or shapes to be found in the classroom itself, or around the school.

If you have a printer and a computer with software for editing digital photographs, your children can publish their own field guides. If you don't have the necessary computer equipment, you can have the photographs printed commercially and paste them onto the pages of your field guide.

New photographs can be added to a field guide anytime, and because you can reuse and edit text and photos with a computer, your field guides can be as dynamic as you and your students want to make them.

Sample Lesson: Field Guide

During our unit on discovering nature around school, we chose to create a field guide with our five- and six-year-olds, who already had lots of experience using digital cameras. We discussed the steps they would need to take to create a field guide and agreed to make a book about the many species of plants found in our school surroundings. Our special focus was on the beautiful flowers growing in and around the school yard. With everyone in agreement, we went right into action!

It was hard to know where to begin. Just outside the classroom, we had some purple flowers calling for attention. Beyond them were lots of yellow flowers in the butterfly garden. Did the children know the names of all these flowers? No, but this was a good time to learn some of them.

The children were eager to practice picture taking. They could hardly wait to get the camera in their hands, and sharing was difficult for them at times. Taking turns was the only way it worked. Eventually each child took several pictures of different flowers.

Later we previewed these pictures on our large-screen TV. The children were very proud of their photographs, and they all wanted to claim each one as their own. I also printed out some of the best shots. We sorted them, named the flowers, and included them in a small book—our field guide. The children loved to look at the book, and they showed it to other children and teachers with pride.

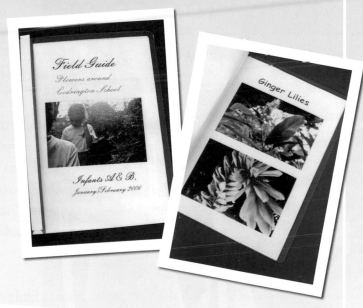

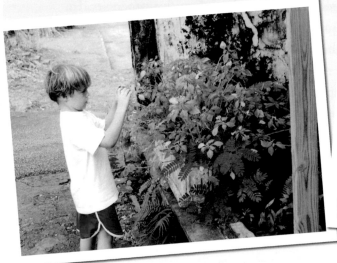

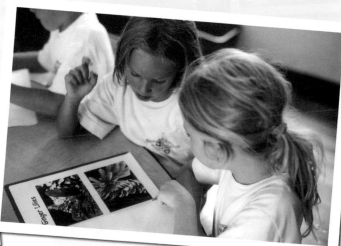

blocks. The next image might show the structure with a few more blocks added, and the next might show one block removed and put somewhere else. You can ask children in general terms to describe how they built this structure. But you're much more likely to engage them by asking procedural questions such as *Why did you do this first? Why did you put this small block on the other and take away the big one? What did you observe?* and *Why do you think your first structure fell apart?*

You can take a similar approach when discussing a series of photographs that show the steps in building a terrarium, planting a tree, constructing a three-dimensional model, or preparing a dish in cooking class. Use the photographs to remind the children what they did, and then ask them questions that promote reflection.

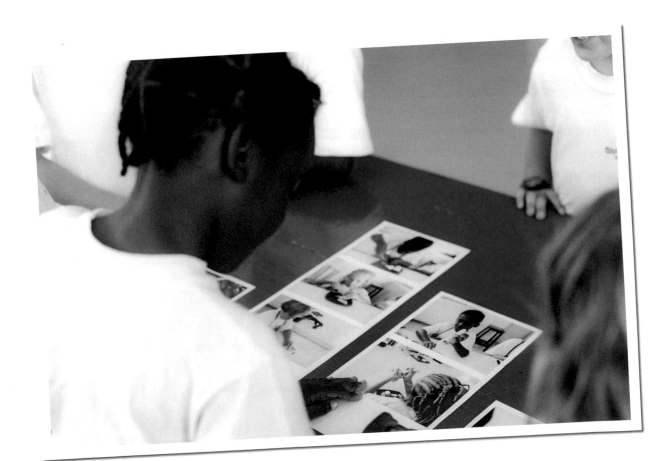

Sample Lesson:
Growth of a Coconut

Remember the coconut seed from chapter 1? Our students can now go to the school garden and see how the coconut tree they planted is growing. But without documentation of that growth, will they remember how it all started? With digital photographs demonstrating the whole process of growth from coconut seed to coconut tree, they will.

Thanks to the photos the children and I took over a long period of time, the process of growth and maturity has been documented for them:

- What our coconut seed looked like when we found it.
- What the coconut looked like when the little shoot appeared.
- What it looked like when we put the seed in water.
- What happened when we planted the seed in our school garden.

As a result, the children began to understand how their actions influenced the growth of the seed. With the help of photographs, my students found it easier to remember what they'd observed and to answer questions about growing a seed:

- What happened to our coconut seed when we put it on the table in the classroom?
- How did we know that this coconut could grow into a tree when we found it?
- What did we do to help our coconut tree to grow and why did we do it?
- What made us think the coconut needed water?

Looking at the photos allowed the children to think about why they did what they did, and about what happened as a result of each step they took. For the children, it made their personal inquiry visible.

The lesson to take from our experience is this: during class discussions, use photographs not only to encourage children to think about what happened, but also to think about what they did, why they did it, what effect their decisions had, how they felt, and how they came to certain conclusions.

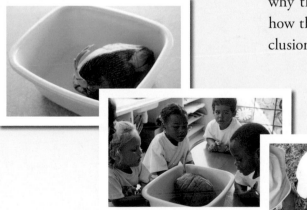

During your science units, every group exploration deserves to be documented so that it can later be reflected upon. While children are actively engaged in collecting data, they are unlikely to be thinking deeply. Help them to become thinkers! Photographs provide children opportunities to revisit specific explorations and encourage them to talk about why they did what they did. Photographs help them recall the steps they took and prompt them to reconsider the challenges in each step. Photographs can stimulate reflection and help children begin to explore not only the world around them, but also the worlds inside their heads.

Organize photographs in ways that children can read and understand. Give them adequate time to discuss pictures, guiding the conversation with simple questions such as *Why did you do this? What did you find out?* and *How did you know?*

Certain kinds of experiences are especially useful for prompting reflection:

- Challenging experiences—perhaps attempts to collect data failed, or the camera batteries died. You can turn such experiences into opportunities for metacognition with questions such as *What did not work well? What can we do better next time?*

- Puzzling experiences—perhaps the data your students collected doesn't seem to support a definite conclusion. You can break through uncertainty by asking *What was our key question, anyway? Do we need a new one? Could we learn more by looking for other kinds of data?*

- Positive experiences—perhaps the children have become excited about an inquiry, experience, or breakthrough in their thinking or action. Bring these moments to awareness and celebrate them with questions such as *What worked well? Why did this activity work so well? What can we do to experience more successes like this one?*

Sample Lesson: Group Reflection

In the pictures here you can see our four- to five-year-old children discussing their project on planting seeds and sequencing the pages of their book about the project. Look at their faces—they are all thinking hard.

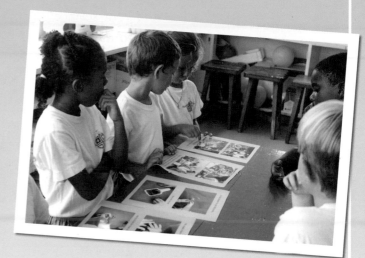

Without photographs of all the steps they took, the children might only have remembered planting seeds in soil. With the pictures in front of them, they realized that they took many steps in a particular order and that everything they did had a reason. So what did they do first, and why? And what happened after that? And then? What did they discover during their project, and what did they like most about it? (There was no question about the last answer: They liked digging their fingers into soil!)

Putting the many pages with pictures in correct chronological order was a challenging task for some children. But working together as a group, they finally figured it out. They were able to recall all of the individual steps they took and their particular reasons for doing so. They were beginning to think about their project as a process of inquiry—not simply as one activity, over and done with.

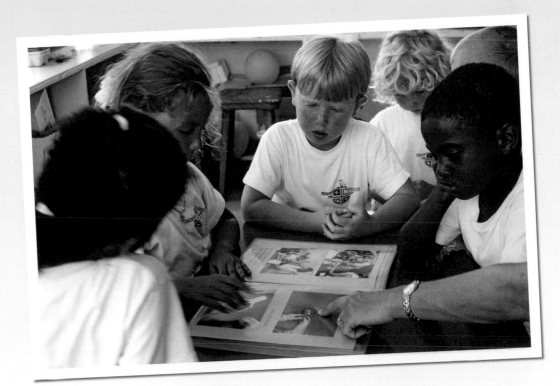

Sample Lesson: Reflecting on a Field Trip Event

In the photograph below you can see our class of five- to six-year-old children reflecting on their field trip to the beach.

With the photographs in front of them, the students could remember various details of the trip, and many of the children had a story to tell. With the help of the photo layout, they were able to make sense of their trip to the beach in the wider context of an inquiry.

The objective of the trip had been to find objects at the beach and to classify those objects into living and nonliving things. As a group, the children reflected by asking and answering several questions:

- Why did they pick up this or that object, and why did they take a picture of it?
- What did they find most interesting, and why?
- What tools did they use for their investigations? Why did they use the magnifying glass?
- What did they find challenging during the trip?

So many things to think about and so many questions to ask and answer! The children remembered much more than just the fun they'd had, and they showed pride in their own process of exploration.

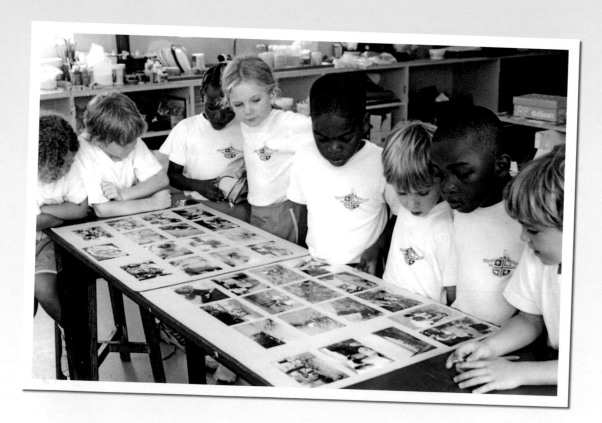

When you sit down with children one by one and show them photographs of themselves hard at work, you show them that their work is important. Using photographs with an individual child can open up a dialogue, allowing him to talk about his experiences during an activity in a deeper way: what he was thinking about, what he tried, and what resulted. Photographs open doors within a child's mind that provide access to memories, experiences, and reflection on her thinking process. You can ask the child pictured in the photograph, *What were you doing when this photograph was taken? What were you thinking about? Why did you choose that particular activity? Was it challenging? Fun? What was it you wanted to discover?*

I'm always amazed by how well this works. Children who struggle to make even a simple statement about what they've been doing can tell complete stories about their experiences after I show them just one photograph of themselves engaged in a particular activity. They've been able to describe how they felt, what went wrong, what they learned, and what they would do differently next time.

So try it out with your class. You'll be filled with wonder at your students' hidden capabilities to read a photograph and use language to reflect on their science experiences.

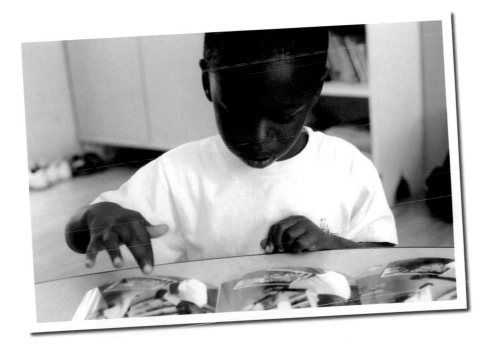

I created and photographed several patterns and designs I'd made using beautiful black and white river rocks that I found in a hardware store. The children love these rocks and use them to create their own designs.

I began by laying out the black and white rocks in different configurations atop colored

"I made a circle out of rocks!"

"Yes, you know shapes very well—it's a circle. But why did you do it?"

"You told me!"

"Did I tell you to make a circle, or did I give you a picture with a pattern on it and ask you to try and lay out the same design with rocks?"

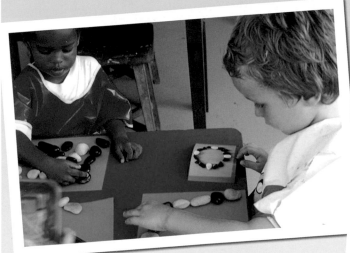

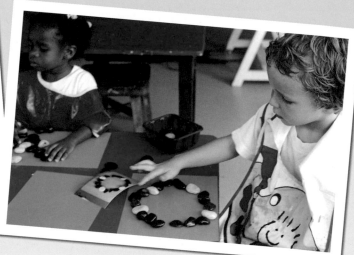

paper and then taking photographs of each shape and pattern I created. I then gave each of the children a photograph of one of my rock patterns and asked them to re-create it with the rocks themselves. Would the children be able to read the given visual information and re-create the pattern correctly? Let me tell you about Ben.

Days after this exercise, I showed four-year-old Ben the photographs I'd taken of him re-creating the circle of rocks. At first, Ben seemed confused, but soon he understood that I just wanted him to look at the pictures and discuss them with me.

"So Ben, what do you see in the pictures? What is it you're doing?"

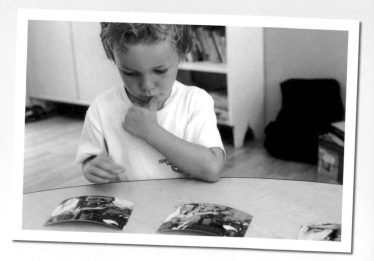

"You gave me the picture."

"So you found out by yourself that you could re-create the circle from the picture!"

"Yes!"

"You see how smart you are! But tell me, how did you do it?"

"I looked at the picture."

"And then?"

"I put the rocks on the paper."

"Are all the rocks the same color?"

"No, they are black and white!" (Silly question!)

"I see you counting in this picture. Did I tell you to count?"

"Yes, I was counting, but you didn't tell me to count."

"So why did you count?"

(Long pause for thinking.) *"To get it right!"*

"Yes, because you are a good thinker and you can also count very well! Counting was a great idea because it helped you to make the design. Now look again. Do you see the same number of rocks on your picture as on the picture I gave you?"

Ben compared the two pictures in front of him and counted the rocks used in each design (mine and his). "No! It's *not* the same."

"But that doesn't matter, Ben. I think you did a great job, and your circle looked almost the same as the one in the picture!"

"I can do it again!"

The second time, Ben got it perfectly right, even down to the correct number of rocks.

It was a new exercise for Ben to sit down and talk about his actions and his thinking processes, but all in all, this was a successful beginning. During our short conversation, he became aware of his thinking skills. He was proud not only of having re-created the pattern but also of figuring out strategies that could solve a problem. Here we have a good example of beginning metacognitive processes.

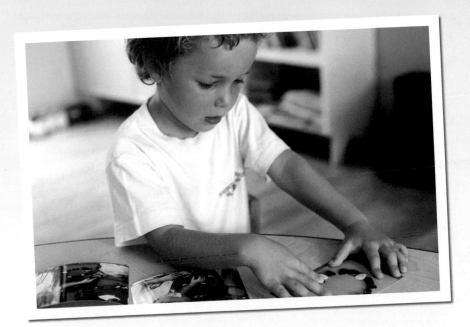

Sample Lesson:
Blocks and Gravity

Working with blocks one day, Darryn learned about gravity and stability. He found out that if he stacked the blocks vertically, his building wouldn't stand for long, so he stacked the same blocks horizontally, thereby making the structure more stable. Smart boy!

While I witnessed his discovery, I documented it with my camera. I wanted to find out if Darryn would be able to talk about and explain why he'd tried stacking the blocks in these different ways. Darryn studied the two pictures intensely as he thought about how he'd stacked the blocks.

He then began explaining what he'd done. One picture showed him supporting his block structure with his hands. He knew why he'd done that: when he didn't hold the blocks this way, they fell over. The second picture showed him building his structure in a different way: with one row of blocks sitting on top of another row of blocks, making the structure strong. No holding was necessary.

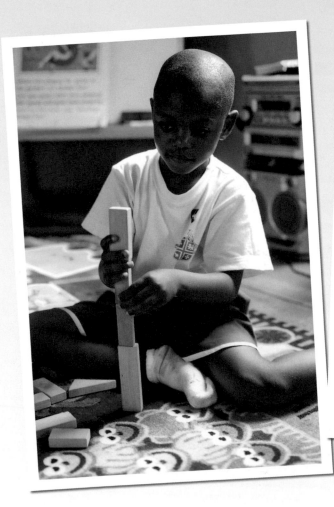

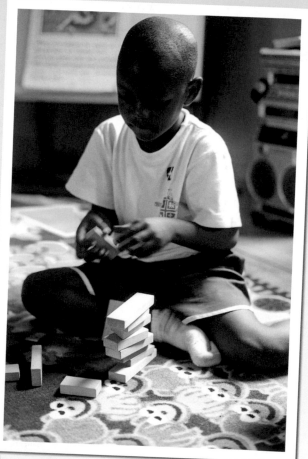

Because Darryn didn't know complicated words like *vertical* and *horizontal* yet, he tried to explain his thoughts with gestures.

He'd solved a problem successfully, and he was proud of it. How did he do it? By trying it one way, thinking about it, and then trying it another way, he discovered how to build a structure that would stand strong and not fall apart in an instant.

Darryn liked the fact that I showed such interest in his work. He also loved the opportunity to reflect on his doings and to express himself.

If you study the photographs of Darryn and those of Ben on pages 72–73, you can see that these children were deeply engaged in thinking. With the help of photographs and your thoughtful questioning, you can open a new world for the students in your care: the world of thinking.

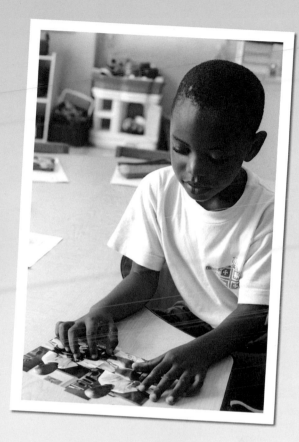

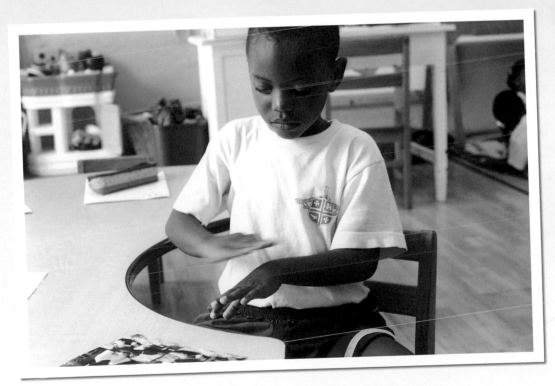

4
Photography for Creating Documentation

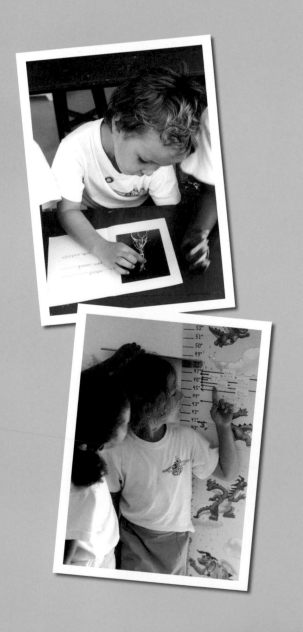

Previous chapters in this book have focused on photography as a way to document science activities for the children in your classroom. Digital photography can also be used to provide a window into your classroom for the larger community. Through photographic documentation in the form of books, presentations, and portfolios, you can present the work of your young scientists to others.

When you involve children in producing documentation, they feel ownership and pride in their work and are only too happy to show it to others—siblings, older peers in school, other teachers, their principal, visitors, and, of course, their parents. When the children themselves are pictured in the photographs, they feel a sense of great importance, and their work takes on even greater meaning. Children feel especially proud when some of the photographs used for documentation are ones they took themselves. Besides knowing that they are valued and appreciated, children develop a sense of responsibility for their own learning.

Digital photographs can play an important role in documenting a child's engagement in activities. When incorporated in a portfolio, they can highlight specific skills a child is developing or point out areas where the child may still be struggling. Photographs can be a valuable tool for communicating a child's developmental achievements and delays to parents.

Photographs can also help you evaluate activities that you planned and implemented.

What worked well, what did not, and why? When you use photo documentation to assess your ways of teaching, you may even come up with new ideas to expand the relevance and impact of your lessons. If you look closely, the photographs may give you new clues about different aspects of your work. Even better, you can show these photographs to other teachers and ask for a critique. Your colleagues may see things from yet another perspective and offer valuable ideas.

Photo documentation can tell a whole story about the project itself, about a child's individual engagement with it, and about *your* work as teacher and project manager. Documenting children's scientific inquiries is particularly important because it communicates the often-overlooked value of science in early childhood education.

Use Photography to Create Books

As you experiment with photo documentation, you may find it useful to create books illustrating projects that children have done in your classroom. These can be set out for parents and relatives to look at when they drop off their children, shown to prospective families, and displayed on parents' nights. You can also make them available in your classroom during the day for children to flip through and recall the different projects they've been part of. You can also help each child create a book to take home and show with pride to his parents.

Books can be made by pasting photographs onto sheets of paper and writing in captions, or you can use photo software on your computer to design your own pages. For example, Microsoft Word can combine text and digital photographs. Most word-processing and all page-layout software can change the size of photographs and crop them. To make pages even more attractive, print them out on colorful paper.

Involve your children in producing photo books. Allow them to sequence the pages in correct order, and teach them to staple pages together. Encourage the children's creativity by encouraging them to make

a beautiful book cover and title page using cardboard, construction paper, or other materials. The more the children are involved in producing photo books, the more meaningful the final results become for them. And when they open their books, who do they see? Little scientists—themselves!

Creating Topic-Related Books

Begin with simple, small booklets using photographs that document specific class activities. Such books, which are topic- or theme-related, can show the various steps the class took in completing a project or inquiry. Topics might include explorations like these:

- How we planted seeds
- Our trip to the beach
- How we built a terrarium
- Our discoveries at the water table
- Mixing colors
- A field guide to our school's natural environment

Creating Yearbooks

Yearbooks belong in every classroom. They offer a summary of important events and children's key experiences. As a record of cooperative accomplishments, yearbooks help children to develop pride in their work as a class. Children love looking at these books and showing them proudly to others: "Look what we did!"

Once you have some experience in assembling topic-related books, consider making a yearbook or a class scrapbook. Such books, which can be organized chronologically or thematically, document class work over an entire term or year. For example, a yearbook can show that during the first term of the year your class conducted several different inquiries related to the growth of a plant and that during the second term you focused on the natural environment around the school. A yearbook offers you a great opportunity to explain your teaching strategies and goals to parents, families, and other teachers.

Put Your Books to Use

Once your topic-related book or yearbook is produced, use it. If you file such a book away or let it sit on a shelf to gather dust, you realize only a fraction of its potential value. Add your topic-related books to the classroom's library and shelve them so that the children have easy access to them. Keep the following suggestions in mind:

- Talk about the books with your children. Ask children to pick them up, page through them, remember some of the excitement they experienced doing past projects, and recall things they learned through their specific experiences. You'll find that yearbooks can be valuable tools for stimulating discussion at the end of a term or school year.

- Use this form of documentation to communicate with parents. Show books to parents when they come to pick up their children. Make the books available at open houses, and consider sending individual topic-related books home with children to share with their families.

- Don't worry about creating books of professional quality. Approach the making of topic-related books and yearbooks in a spirit of play and experimentation. Remember that your overall goal in documentation is to make learning visible. Keep the process simple, and involve your students as much as possible.

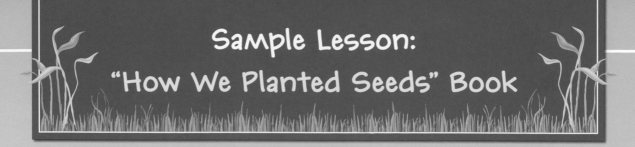
As part of our inquiries about seeds, our four- and five-year-olds planted bean and pea seeds in soil and observed what happened next. This was a long-term project that occurred over three weeks.

In planning this lesson, I considered it important that children begin to understand that everything happens in a certain order and that even the planting itself is a process that can be divided (and described) in several steps. I decided to create a small book about our project that the children could use to recall the events. They could also use it to demonstrate their knowledge by showing it to others. With these ideas in mind, I took digital photographs of our planting activities.

How did the children plant the seeds? Just by sticking them into soil? No, they had to do much more. We began by discussing the children's ideas about what seeds need to grow into plants.

We then went outside to get the necessary materials—planting cups, little rocks, and soil. Back in the classroom, we put the pebbles at the bottom of the little planting cups and added the soil on top. What was the reason for putting pebbles at the bottom? Some children had no clue, while others guessed correctly: to hold water. Next, we poked holes in the soil and stuck seeds in, after which we covered the seeds slightly with soil and watered them.

After a few days, we saw some tiny plants growing out of the soil. Unfortunately, not every child was happy with the results. Some seeds didn't grow at all, and some even began to rot. What was the reason for that? The children were asked to come up with an explanation. "The seed was ill," one of them said. "The seed was dead." "It had too much water (or not enough water)." "It did not get enough sun (or it got too much sun)." All of these explanations demonstrated a dawning understanding of cause and effect.

Over a period of two weeks or so, we collected enough photographs to create pages for our *How We Planted Seeds* book. I asked the children to help me put all the pages in chronological order. Everyone wanted to get the story right. Although some of the children were still too young to put all of the photographs in order, by looking at one page at a time, all the children were able to relate the pictures to their experiences during the seed-planting activity.

Now we have a nice little book about our project to reinforce learning and to present proudly to others!

Digital photography helps you to create presentations to use during school open houses, school meetings, parent conferences, and on occasions such as workshops for teachers and staff development meetings. The latest technology gives you countless options, including slide shows and multimedia presentations—even a class Web site.

Microsoft PowerPoint is the standard software for creating slide-show presentations on a computer. With it, you can project digital slides onto a large screen or a TV or produce a DVD. PowerPoint can incorporate photos, text, clip art, charts and graphs, sound effects, animation, and videos into a slide show that can make a powerful impression on your audience. Of course, it takes time to learn these features, and your use of such software depends on your knowledge of and interest in computer technology.

If you're interested, just dive into presentation software—try it out, play. There's much you can learn through simple experimenting. Also take advantage of Web sites that offer free help in learning how to use Power-Point. I have enjoyed PowerPoint in the Classroom (www.actden.com), which explains this software in an entertaining and easy-to-follow manner. If you are a teacher who sees yourself as a lifelong learner, spend some time getting acquainted with this technology. Your effort will pay off in expanded options for classroom activities. When creating presentations, I have found it helpful to keep several points in mind:

- Make sure your presentation includes plenty of photographs of the children doing science—not just photographs of objects or events they're studying. Make the inquiry process clear for parents and other adults by showing the children in action as they do science.

- Bring the audience through the whole process of inquiry, from beginning to end. Answer key questions: *What did the children want to find out? How did they go about collecting and analyzing data? What conclusions did they reach?*

- If you're using PowerPoint and want to insert text along with the pictures, include as many quotations from the children as possible. What did the children say during the inquiry? What were they discovering? For parents, even simple quotations such as "The seed is brown and has a coat" can add a great deal of meaning to the presentation.

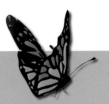

Use Photography for Assessment

Digital photography can be a powerful tool for assessment. You can use photographs to create a lasting visual record of how children are developing, what skills they are attaining, and where they might be delayed. In early childhood education, assessment can include portfolios and parent reports.

Create Portfolios

How can we present the active learning that takes place in our classrooms—children working successfully to solve a challenging puzzle on the floor, creating a three-dimensional piece of art, working in their school garden, participating actively in classroom discussions, playing learning games, working on group projects, and learning new things on a field trip? One easy and excellent way is to document children's active learning with photographs and make these images part of each child's portfolio.

Portfolios are systematic and meaningful collections of student work. They demonstrate progress over time in one or more subject areas and showcase the student's best work. Work included in a portfolio can incorporate a variety of media, both paper- and digital-based, and can be used to evaluate a student's developing abilities.

Often children don't want to wait until a term has ended to show what they've been doing in school. They want to take their work home right away to show their families. A great way to fulfill this wish is to snap some

photographs of the children's work so that you have records of it for their portfolios.

Portfolios can greatly enhance a teacher's opportunities to communicate with parents about their child's learning progress. After all, parents often have only a vague idea about what or how their child is doing in school. Pictures of their child actively engaged in various learning activities give them much better insight. A portfolio that includes pictures of the child engaged in a learning activity can tell much about class involvement, individual learning style and abilities, general progress, interests, and strengths.

Using photographs in portfolios also offers a great way to communicate with parents who are English language learners with limited English reading abilities. These parents can see their child in action and understand much more about how the child is doing and what's going on in your classroom.

When creating portfolios, solicit input from teachers, parents, school administrators—and children. Remember when you're choosing representative work samples that it's important to let your students play an active role in putting their portfolios together. This activity allows children of any age not only to select representative pieces of their work but also to establish criteria for what is selected. As a result, they learn to reflect on their learning and begin to assess their work independently. Having self-assessment skills is important for later success in school and in the workplace.

Keep ongoing records of students' work in digital photo files on your computer. Return to these files each time that you make additions to their portfolios.

Trinity's Portfolio

Trinity made a beautiful painting of flowers. She could, of course, show her painting to her parents. But would they know that she'd created it by observing a bunch of flowers that were put on the table during the science and art activity? Taking photographs of Trinity painting the flowers and including them in her portfolio revealed that she was not only a skillful artist but a careful observer as well. Look at the colors of the flowers and then look at her painting. She did an amazing job! By providing additional information in photographs, you can present children's skills more accurately.

Fayola's Portfolio

Fayola's portfolio included a photograph of a painting activity that was both a science and an art experience. In Fayola's painting, you can see that she gave her flowers roots. Photographs in Fayola's portfolio explained why she made the painting as she did: she observed several complete flower plants lying on the table and then demonstrated her conclusion—all plants have roots.

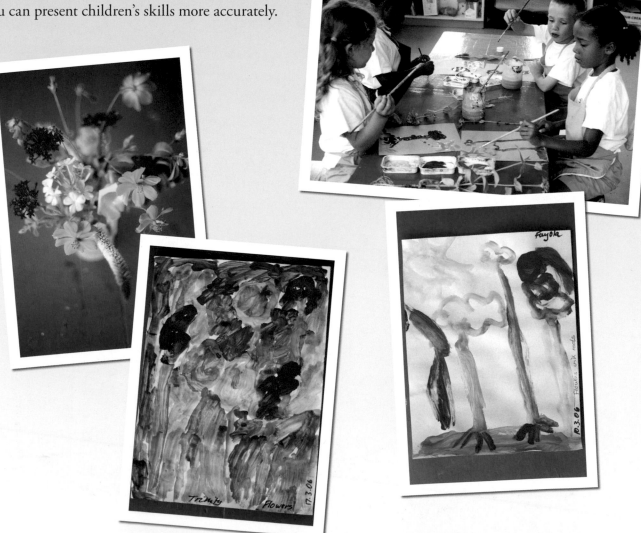

Christopher's Portfolio

Christopher created a picture of a tall building by pasting construction paper shapes onto paper.

If his parents saw only the final product, they could admire Christopher's great artwork, but they wouldn't know he'd made it as part of a science project about high buildings.

The children studied pictures of actual skyscrapers on the computer and then built their own structures using cardboard boxes. They then created two-dimensional representations of their towers using construction paper squares to help them further reflect on how they built their structures.

Christopher enjoyed building structures and experimenting with balance and gravity. Photographs taken during the project demonstrate how he used his developing thinking and planning skills and show how creative and successful he was during these learning projects.

Christopher built his own tower using cardboard boxes. Whoops! It might fall! Christopher learned something about gravity, stability, and balance.

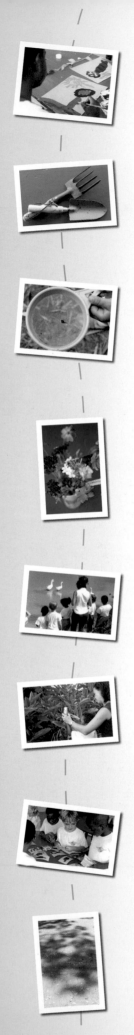

Create Parent Reports

Like portfolios, parent reports are a tool for improving communication between students, parents, and teachers. Parent reports demonstrate students' progress and performance, helping parents to understand how their children learn.

The design of parent reports in early childhood programs varies greatly among schools. Reports are most effective when they provide information that accurately represents the expectations of the school's program. Reports should give a clear statement about a student's performance within this context and present a comprehensive and accurate picture of that child's major strengths and weaknesses. The aim is to provide parents with understandable information about their child's development.

What does such documentation look like in early childhood programs? How do we explain our standards to parents? Documenting children's progress can be done in many ways other than through tests and grades. One way is to use photography. With digital photography, teachers assess and document children's active engagement, individual strengths, specific interests, ability to conduct an investigation, and the kinds of things that fill them with wonder.

Digital images can reveal, for example, how much interest a child has shown in scientific investigations. Some points to consider when observing and assessing a child's inquiry skills are:

- Was the child able to make observations?
- How well did the child communicate these observations?
- What fundamental concepts is the child able to comprehend? Did the child develop the ability to distinguish, for instance, between living and nonliving things or between natural objects and objects made by humans?
- How far developed are the child's abilities to compare, sort, and classify?

Photographs taken of individual children during a science activity may provide visual answers to some of these questions. Use photographs to support your comments about children's performance. Take photographs of things they've made or activities they've been involved in and to accompany the photos, write descriptions of learning goals, standards, and actual performance during given tasks. Photographs are a form of evidence and can inform parents about their children's learning in an authentic and detailed way. In fact, pictures that are included in a report card may tell parents more than words or check marks do.

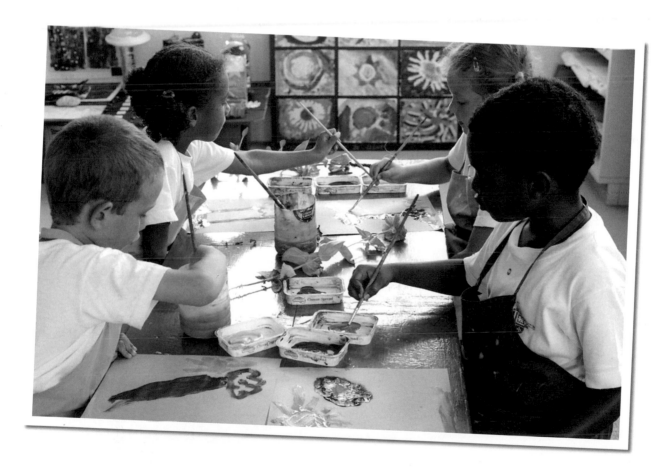

Sample Parent Reports

Parent Report for Laurrent

During a recent term, we explored nature around the school and took a closer look at seeds. Laurrent showed a keen interest in these investigations and was enthusiastically engaged in all of the science activities. In the process, he learned how to use a magnifying glass. After he found a little worm in this seed bud, the class decided to learn more about how worms behave. Here we have a young scientist in the making.

Parent Report for Alessia

As part of our studies of trees, we first observed trees and then drew and painted pictures of them. Alessia demonstrated well-developed observational skills and the ability to give her knowledge form. Look at her painting of a tree: she recognized the shape of a tree and that trees have a trunk.

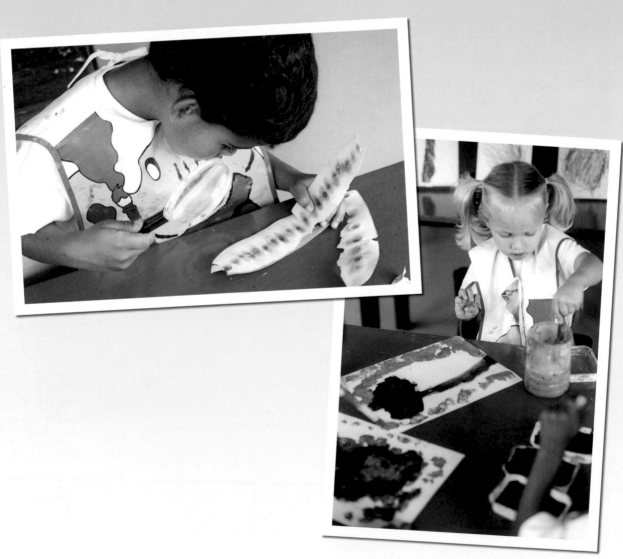

Parent Report for Taylor

Taylor likes to play with blocks, and she can create all kinds of interesting buildings. She can focus on a block-building activity for a long time if others don't interrupt her. If she's not satisfied with the result, she will change it or start all over, again and again. She has demonstrated a long attention span during learning activities.

Parent Report for James

James learned a new skill: how to take photographs. He was able to use a camera appropriately and to take great shots. He showed intense interest in our study Animals and Their Habitats and took several pictures for our display.

Appendix:

Technical Questions and Answers

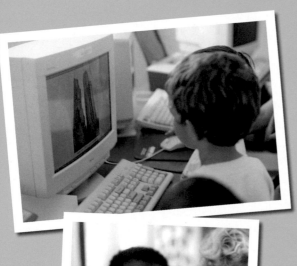

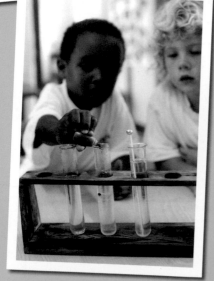

As I stated earlier in this book, you don't need to be a professional photographer to use photography in your science teaching. Using a digital camera is surprisingly easy, so there's no reason not to try it. I tell our students every day to step out of their comfort zone and try something new. That's learning, and you can model it!

I've met many teachers who are afraid of computers, digital cameras, and other new technology. But what is there to fear? It's fun to learn new skills, especially those you can play with so creatively. The beauty of digital photography is that you cannot mess up! If you take a picture you don't like, you can just delete it and try again.

But what if you're not familiar with terms such as *megabyte, pixel,* and *resolution*? No need to panic! Every camera comes with a set of instructions, and it's not too hard to understand the basics. Megabytes on your computer don't bite, and your camera's pixies—sorry, *pixels*—won't transport you into a strange world and surely won't harm you.

So what are you waiting for? Get a camera and try it out. Your five-year-old students can do it, and so can you.

There are many affordable digital cameras on the market, so choosing one can be a challenge. The questions and answers that follow can help ease your transition into digital photography.

How Much Money Do I Need to Spend?

Digital cameras are available in a wide range of prices. Your children can practice taking pictures with a very cheap camera, but you may want something better.

I recommend buying a camera in the middle price range. Such cameras provide you with many options. They can produce larger, higher-quality posterlike prints than can the lower-quality cameras that lack the pixel capacity (see below) to make big prints. Middle-range cameras also offer *movie mode,* which allows you to shoot short movies and usually to record sound as well. Let your school budget be the guide.

What Resolution Do I Need?

In order to answer this question, you need to understand two terms: *pixels* and *resolution.*

Pixels

Pixels are the tiny dots that make up a digital image. The term is an abbreviation of two words: *picture* and *element.* Each pixel is a microscopic element of the picture. Pixels are expressed as the numerical values in a width-by-height measurement—for example, 800 by 600 pixels (width by height). The term *megapixel* means one million pixels. It results from multiplying the number of pixels in width by the number of pixels in height. A camera offering 1,600 by 1,200 pixels creates a resolution of about one-and-a-half megapixels.

Resolution is the number of pixels per square inch in your image. The sharpness of your digital image depends on its resolution. A higher resolution gives you crisper, higher-quality images.

There's a trade-off here: the higher the resolution, the better the quality of your image—and the larger your file size is. And larger file sizes mean that downloading your images takes longer. Larger images also take up more of your camera's and your computer's memory.

The lowest resolution on digital cameras is 640 by 480 pixels (640 wide by 480 high). This low resolution works well for e-mail and Web postings and for simple, small classroom printouts.

Personally, I appreciate a photograph with high resolution. But you'll discover that your students aren't critical when they look at printouts—they're much more interested in the content of a picture than in its quality.

Who Will Use the Camera?

Think about how you'll use the camera in your classroom. Simple, inexpensive, or low-resolution cameras are often the easiest for younger students to use. But if it's *you* who'll be doing most of the work with this camera and possibly tackling some advanced projects, then opt for the highest-quality camera you can afford.

Will a Camera Be Too Fragile for My Students to Handle?

Young children can become very capable in handling a camera, and being trusted with such an important piece of equipment fills them with pride and a sense of responsibility. Many of the digital cameras on the market today are compact and quite durable. As you consider the design and size of a camera, keep your youngest students in mind: will the camera fit in their small hands and will they be able to access its buttons easily?

What Image Storage Capacity Do I Need?

The more images you can store, the better-off you'll be. When you shop, ask the sales person for specifics about how many images each camera can handle. Most digital cameras come with an internal memory, but this memory capacity is usually quite small, so you'll probably want to buy a memory card.

The higher the storage capacity is, the more photos you can keep in your camera. Storage capacity varies depending on the brand of the memory card, the subject of the picture, and the resolution you choose to use. Higher resolutions use more storage capacity on memory cards than lower resolutions do. If you plan to use the movie mode on your camera, make sure you have a lot of storage capacity available, as video clips fill memory space quickly.

There's a wide variety of memory cards on the market, from those with a low storage capacity (two, three, or eight megabytes) to those with a high capacity (five hundred megabytes) and all the way up to those with a capacity of one gigabyte or more. You probably won't need a gigabyte of memory, but I recommend that you initially invest in a card with a storage capacity in the hundreds of megabytes. For example, a 512-megabyte card will give you the opportunity to store over seven hundred high-resolution (5.0 megapixel) images and over twenty-five hundred low-resolution (1.1 megapixel) images, and will also have enough space for twenty-three minutes of video storage.

Having adequate storage capacity is important. You don't want to run out of storage space in the middle of a photo shoot—you'd either have to delete some of the images you'd already stored in order to continue, or you'd have to stop shooting. Deleting pictures on the spot in order to create storage space can be distracting, and weeding out undesirable images is work far better done when you have the time to do it thoughtfully. To avoid running out of space, keep a spare high-storage capacity memory card with you when taking pictures. You'll be far less likely to run out of storage space.

What about Battery Capacity?

Because digital cameras use up battery power rapidly, maintaining battery power can be a challenge. And if your camera shuts down because of dead batteries, an exciting photo activity will suddenly come to an abrupt end. To help prevent such an occurrence, buy a battery charger and use rechargeable batteries. Plan your photo shoot carefully, and make sure your batteries are fully charged first. And always keep a set of spare batteries on hand.

Remember that rechargeable batteries lose part of their charge each day, whether or not the camera is being used. Unfortunately, most digital cameras do *not* tell you how much battery power you have left. When your battery power is very low, the indicator won't start to blink until shortly before your camera shuts down. The only solution to this problem is to always keep a set of fully charged spare batteries on hand.

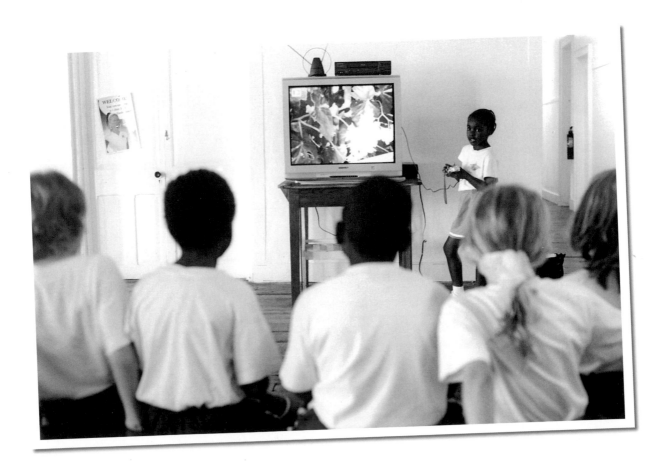

What Features Are Most Important?

Red-Eye Reduction Mode

You'll find this feature on most digital cameras, but it can be tricky to use. *Red eye* occurs when the camera's flash bounces off the cones in the retina of your subject's eye. We've all seen the result: the person in your otherwise perfect photo has devilish-looking red eyes.

Red-eye reduction mode provides a pre-flash that allows the subject's eyes to become acclimated to bright light. Unfortunately, the pre-flash may also make your subject blink. Trying to avoid red-eye this way can introduce a problem just as bad: the people in your pictures may have their eyes closed instead!

For this reason, I rarely use the red-eye reduction mode and also try to avoid using the flash. Pictures taken in daylight without a flash are much nicer, anyhow; they capture natural, soft light instead of the flash's harsh light. Natural light also gives you more accurate color and detail.

For indoor shots, you can brighten up the area where you'll be photographing by turning on a few more lights. Before taking pictures, ask the people you want to photograph to look first at a light so that their pupils can contract and acclimate to the brightness.

When taking pictures outside, find a shaded area. Finally, avoid the full, bright sunlight at midday.

Optical Zoom Mode

Pay some attention to the quality of your camera's lens and its optical zoom capacity. This is usually given as a number followed by an *x*, such as *2x* or *3x*. The higher the number is, the greater the magnification.

You needn't pay much attention to the camera's *digital* zoom, which is not the same as optical zoom. Digital zoom simply blows up the center of an image, and in doing so decreases the number of pixels recording that area. This results in lower resolution, which can make the picture seem fuzzy, particularly if you choose to make a large print of it. Optical zoom, on the other hand, changes the frame of the image by eliminating what lies to either side, so the subject is magnified optically. This occurs without sacrificing resolution and so creates images that can be blown up without

sacrificing much quality. If you want a digital camera that offers zoom capability, look for one with *optical zoom*.

Self-Timer

The *self-timer* enables you to set up the camera so that it automatically snaps a picture several seconds later. This means that you or your students can set the timer, come out from behind the camera, and include yourselves in the photograph. Make sure you have this function on your camera. Set the camera, click, and *run*. You'll be in the picture now, but perhaps not in the most pleasing and presentable way. Try again!

Movie Mode

Most digital cameras have a *movie mode* that enables you to film short movies. You can do fantastic projects with this, and once you've mastered still photographs, I hope you'll find the courage to explore movie projects. When thinking about this feature, consider how much it adds to the price and what demands it will make on your camera's storage capacity. If you plan to use the movie mode on your camera quite a bit, you might think about purchasing a memory card with a very high storage capacity, one gigabyte or more, for your camera. You can find exact information about how many minutes of video can be filmed with different storage capacities in the camera's instruction booklet. Consult this guide when you're deciding what size memory card you'll need.

Delay Time

Unlike film cameras, most digital cameras have a delay time between when you press the shutter release and when the actual picture is taken. For this reason, shots intended to capture swift action may fail to do so. For example, because of the delay time, if you're trying to capture the moment when a child is jumping in midair, you may actually end up with a picture of the child landing.

Newer models may have shorter delay times. When purchasing a new camera, ask about shutter delay, as you're unlikely to find any mention of it in the camera's instructions.

If your camera has a long delay time, you can work around it by focusing on still pictures. Ask children to stand still for a second when they're posing for pictures, or help them hold the camera steady when they're shooting a picture themselves. If you want to capture action, you might try using the camera's movie mode.

Will the Camera Be Compatible with My Computer?

Before you buy a camera, be sure to ask the sales person whether it is compatible with your computer. Camera and computer must be connected in order for you to copy and print the images you and your class shoot. When purchasing any camera, make sure it is compatible with your computer's operating system (such as Windows 98, Windows Me, Windows 2000, Windows XP Professional, Macintosh OS9 or OSX).

To connect your camera to your computer, you need a USB (Universal Serial Bus) port and cable. These provide a standard connection for transferring data relatively swiftly. Digital cameras come with their own USB cable and USB driver. The latter is software provided on a CD-ROM that you can install on your computer to allow communication between camera and computer.

Will the Camera Work with the Software That's Already on My Computer?

Tell the sales person what software you are using and ask whether the camera you're considering is compatible with it. Usually it will be.

Every digital camera comes with its own photo-editing software, which you then download to your computer. You can use this software or choose another program—something simpler or more advanced. Editing software allows you to download photographs to your computer, delete unwanted pictures, store and edit those you want to keep, and organize them into folders. You can also use it to crop photos and to change their quality (for example, their size, color, contrast, and resolution).

How Do I Print Photos?

You can print out your pictures on plain photocopy paper or on high-quality photo paper. Another option is to store your pictures on a CD-ROM or a flash drive ("memory stick") and get them developed at a photo store. Your choice depends on your budget. Remember that children are not very critical when it comes to the quality of a photo print; what speaks to them is the content of the picture.

How Should I Store Photos?

It makes a lot of sense to develop a system of organized, accessible electronic folders on your computer. You can use these files repeatedly; they will always be available for new and different purposes. In time, you'll develop a solid data base of images that other people can use too.

You can also store some of your older files on CD-ROMs or on an external hard drive. You can then delete these files from your computer, thus making space for new data. Even years later, you can still retrieve pictures from old investigations. This can be useful when you want to introduce to a new class of children a topic you've discussed in the past, or when you want to demonstrate changes in student development over a long period of time.

Developing this level of organization on your computer can be time consuming, but the results are well worth it. Consider asking older students to help you with the task, perhaps as an assignment for one of their computer classes.

How Can I Take a Successful Picture?

A painter uses a brush and paint to create a picture; a photographer uses light. All cameras work with the same input: light that is reflected from your subject and passes through a lens. This light exposes a section of film or, in a digital camera, alters an array of light-sensitive electronic chips. These chips emit electrical charges that are then converted into pixels and stored in the camera's memory.

Beyond this basic starting point, cameras have different features. In order to use its features effectively, you have to get to know your camera. Take your time becoming acquainted with it, and be willing to learn from your mistakes. Try to think of your camera as a new friend you're getting to know.

Please be patient with yourself. Remember that with a digital camera you don't waste anything except battery power when you make a mistake. If you don't like the picture you just took, simply delete it.

With any new camera, you need to adjust some settings before you can take pictures. Unless you know someone who'll adjust the settings for you, there's probably no way around reading the instructions. In any case, the camera doesn't work by itself. It's up to you to make it work.

Here are some additional tips for taking successful photos:

When Possible, Use Daylight

Daylight is always best. When taking pictures, make sure you have the source of light behind you and shining on the person or object you want to photograph. This helps you avoid silhouette-like images.

Keep the Background Simple and Uncluttered

Pay attention to the background in your photographs. A lot of activity in the background or one that is loaded with patterns can be distracting and produce a cluttered image.

Get Closer

I've observed that most children with a camera in their hands have no problem getting close to a subject. Many adults, however, stay much too far away, which results in pictures that include lots of unwanted visual information.

Remember the purpose of the particular picture. Avoid showing more—or less—in your picture than what you have in mind. If you want to take a picture of one leaf, you needn't photograph the whole tree; if you want to show one person, you needn't photograph everything surrounding her. Unless you're taking a photo of a wild monster, there's nothing to fear! Step forward and get the shot. Close-up shots are impressive.

Of course, you can always crop your pictures afterward, on the computer. Keep in mind, however, that this results in a loss of resolution when pictures are enlarged for printing.

Don't Get Too Technical

Digital cameras offer a lot of bells and whistles, a lot of technical niceties. The key thing is to try out the camera and learn from your mistakes. Use the digital camera as a tool to enrich your students' learning. Most important of all: be creative in using the camera and have lots of fun with your students!

The old saying is true: "A picture is worth a thousand words." And it can also be used in a thousand different ways!

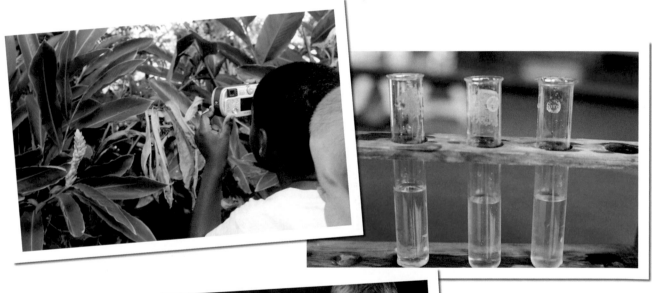